Winged Victory
Altered Images
Transcending Breast Cancer

Photographs
by **Art Myers**

Poems
by **Maria Marrocchino**

Foreword
by **David Spiegel, M.D.**
author of *Living Beyond Limits*

Photographic Gallery of Fine Art Books
San Diego, California

Library of Congress Catalog Card Number: 96-68207
ISBN 1-889169-00-5

SPECIAL SALES

ATTENTION PROFESSIONAL ORGANIZATIONS, CANCER SUPPORT GROUPS, CORPORATIONS AND COLLEGES AND UNIVERSITIES. Quantity discounts are available on bulk purchases of this book for educational training purposes, fund raising, or gift giving.

Original photographs are available for exhibition and/or purchase.

For information contact: Photographic Gallery of Fine Art Books. PO Box 370175, San Diego, CA 92137.
(619) 221-0340.

PRE FACE

I am still haunted by the memory of the phone call from my mother telling me in a trembling voice that my sister Joanne, still in her thirties, had been diagnosed with breast cancer. Following a prolonged heroic battle to survive she was to eventually die from that disease. Two decades later I anxiously faced a surgeon in an antiseptic hospital waiting room as he uttered the dreaded words, "Your wife has breast cancer."

In my career as a physician I have many times had the sobering responsibility of delivering the news of a cancer diagnosis to patients and their loved ones. However, I was not prepared for the overwhelming effect that breast cancer in two close family members would have on my life. I began to see the disease in a new light. I learned that anxiety about survival, initially the most important worry, can give way later to a new unease both in the survivor and her partner. The woman may begin to cover her nakedness fearing a spouse's averted glance, or turn away from the reflection in a mirror that unremittingly reminds her of fears of diminished femininity. A partner withdraws a hand to avoid touching a scar where once was a graceful curve. Lovers draw apart, an absent breast now a barrier to their intimacy. A fiancé quietly turns his back and walks out of a cancer survivor's life. These fears about body image, femininity and sexuality are understandable in a society that is bombarded by media messages of centerfolds, push-up bras and silicone implants – messages that erroneously imply that a perfect breast is the requisite icon of the feminine essence.

With the support of my wife Stephanie, now almost a ten year survivor and one of the women in the book, I undertook this photographic project hoping to show that a woman's fundamental nature is not dependent on anything external; the loss of part or all of her breast is not a threat to her being. The short narratives, written by the women and their partners, are included as an important part of the message. With no substantive editing they come right from the subjects' hearts, printed as written. The beautiful poems were created especially for this book.

In my other career, that of fine art photographer, I have been photographing women for a decade and a half, but it wasn't until I started this project that I began to understand the many elements that make a woman's image complete. Now it is my hope that these pictures, poems and personal vignettes will reveal the persistence of a woman's beauty, strength and femaleness in all of its complexity, even after the transforming experience of breast cancer.

by Art Myers

Acknowledgments

My special thanks to the following people whose hard work and artistic expression made the completion of this book possible.

Maria Marrocchino, who wrote the exquisite poems exclusively for this book,

Karl Tani, who produced the book design and other artwork,

David Spiegel who wrote the foreword, and especially,

Dani Grady who worked with me from the beginning in
conceptualizing and promoting this project,
and recruited many of the photographic subjects.
Her constant enthusiasm and encouragement
were largely responsible for my completing this project.

This book is dedicated to my wife Stephanie, to the
memory of my sister Joanne, to Dani and Andrea,
Susan, Carol, Dora, Joel, Ulla, Connie, Karen,
Yavonne, Lisa, Tanya, Maryann, Louise and all the
other women in my life whose own lives have been
touched by breast cancer.

The publication of this book was made possible, in part, through a seed grant from The Breast Cancer Fund, a national nonprofit organization that raises awareness and funding for cutting-edge projects in research, education, patient support and advocacy.

A portion of any profit from the sale of this book will be donated to help fund breast cancer support programs and promote breast cancer awareness.

FORE WORD

There is great beauty in a woman's form. Yet what is it that is so endlessly fascinating about it? It is not simply the curves, the pleasingly familiar yet forever varied arrangement of breasts, stomach, thighs. It is the spirit which moves her, makes her part of something more. Thus the Winged Victory of Samothrace stirs one not as a piece of stone with arms amputated and wings attached. As one approaches it from below and climbs the staircase to it in the Louvre one's breath is taken away by its power: female strength transcending the ravages of time.

The images in this book are of female strength. There is no pretense here, no gaze averted. One woman diagnosed with breast cancer in 1942 was told never to show her scar to her husband. Bad advice. She flourished in the ensuing half century with a husband who was quite willing to see and touch all of her body.

Breast cancer is not a good thing, and the loss of a breast is something nobody wants. Yet when it happens, the women in this book are telling us, you are forced to reassess the beauty in your life and in your body. Hiding the loss, the scar, implies shame. It then is not merely the breast that is gone, but yourself as a woman, as a source of beauty, as someone deserving tenderness and the admiration of a lover.

The women in these photos did something different. On these pages they say, "Here I am." They are redefining their beauty: breasts missing, reconstructed, they present their bodies and themselves with humor, sadness, vulnerability, honesty. They challenge us to look beyond what is missing, beneath the scar. They evoke admiration: of their beauty and their courage. They do not hide their loss, they transcend it.

I have listened to groups of women with breast cancer for some two decades. None are happy about the disease or its effects on their bodies. But they yearn to be treated as people, not cases, to be seen as the women they are, not as "damaged goods." They learn not to retreat from cancer but to live with it: "I realized one day that in order to fully accept who I was, I had to learn to love my cancer. It is a part of me, like it or not. To love myself I had to learn to love it." They learn to focus on what they are, rather than what they are not.

The paradox is that in order to be appreciated for who you are, you have to admit being something others may fear or dislike: "tainted by cancer." By saying openly, "I have cancer," you can get on to "now what?" I am this, but I am also more than this. I am a woman, a lover, a friend, a wife. These women say to other women with cancer, "Don't hide your cancer from yourself or anyone else. Admit it and live beyond it." They also call on us to re-examine what constitutes beauty, both physical and mental. These women and their men are beautiful and interesting, each in their personal way. They make the viewer comfortable because they are comfortable. They show us that they can live with and beyond their cancer, the damage to their bodies, the threat to their lives . It is not easy, but it can be done. They show us how. Enjoy them. They remind us of what is vital and beautiful in life.

by David Spiegel, M.D.
Professor of Psychiatry & Behavioral Sciences
Stanford University School of Medicine
Author of *Living Beyond Limits:*
New Hope and Help for Facing
Life-Threatening Illness.
Ballantine Books, 1994

Sisterhood

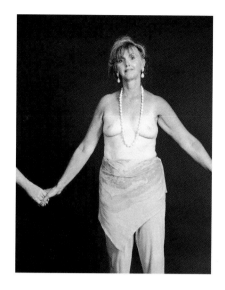 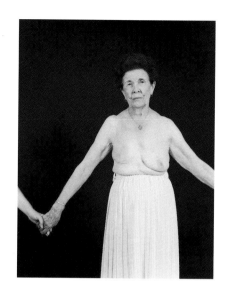

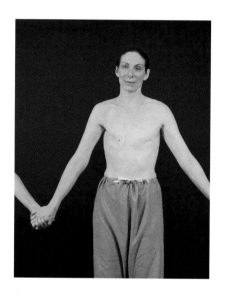

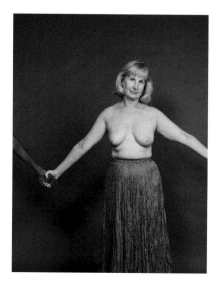 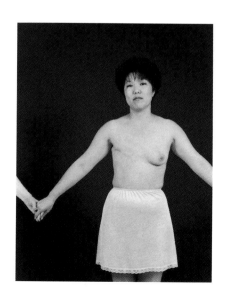

W hen I was diagnosed with breast cancer as a young woman of 29, it was easy to despair at the perceived loss of my figure and dating future. I had never seen a women depicted in our pop culture as a "mastectomy beauty." The gift of a lifetime came to me from the sisterhood of strangers who reached out to share their metamorphic journey from breast cancer victim to woman of substance.

As executive director of the University of California San Diego Cancer Center's Thrivers' Network, a cancer patients support program, I have met many breast cancer survivors who are truly phenomenal women. They exude beauty, strength and confident femininity. For years I envisioned a photo essay reflecting this spirit. In my original concept the photos would capture the women in elegant poses with leis and necklaces averting the eye from imperfections while retaining the classic notion of beauty.

Then I met Art Myers.

He thought it was vital that the women openly expose their scars. This revelatory act would also make acceptance a visible and essential concomitant of beauty. Art was passionate on this point. He had been dreaming of this project since his wife Stephanie's treatment for breast cancer.

He was right. We have all known that when a woman facing breast cancer asks her doctor to show her a picture of a woman who has had breast

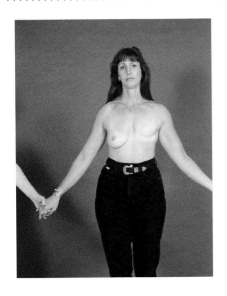

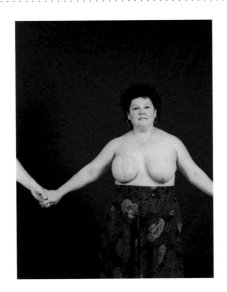

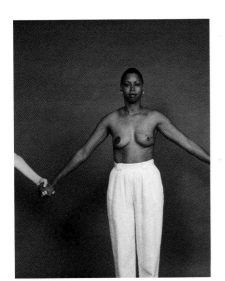

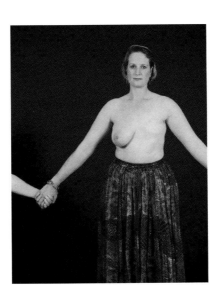

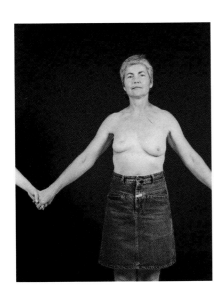

surgery, she is shown a photo from a textbook of a scarred disembodied torso in harsh clinic light. In this impersonal context, the loss of body parts and marks of the knife "are disfigurement."

This alienation from ourselves was a common experience for many of the women in this project. One by one we came to see our involvement as a way to change perception. This became our rallying point. We gained unity and strength in our determination to set the record straight. When I approached Dora, an eighty-three-year-old church-going great-grandmother and fifty-year survivor she immediately said "I will, I absolutely will! Nothing has changed in the past fifty years!"

The women in these photos have revealed the most private aspects of their lives. They have done so as a gift of mentoring and in hope for change.

The models come from varied backgrounds. They are a lawyer, nurse, secretary, professor, executive, activist, clerk, administrator, radiology technician, psychologist, school teacher, and homemaker. No one had posed nude before or even had the desire to do so. There was a common feeling of modesty, some being more shy than others. Most were skeptical of their ability to convey their sense of beauty to the camera. However, no one has regretted her participation and all are very proud of their photos.

With the progression of this project I witnessed in these women an enhanced sense of self-esteem and pride in their bodies. There is now no secrecy shadowing the metamorphosis of their self image. Revealed are women of substance, the *sisterhood*. – Dani

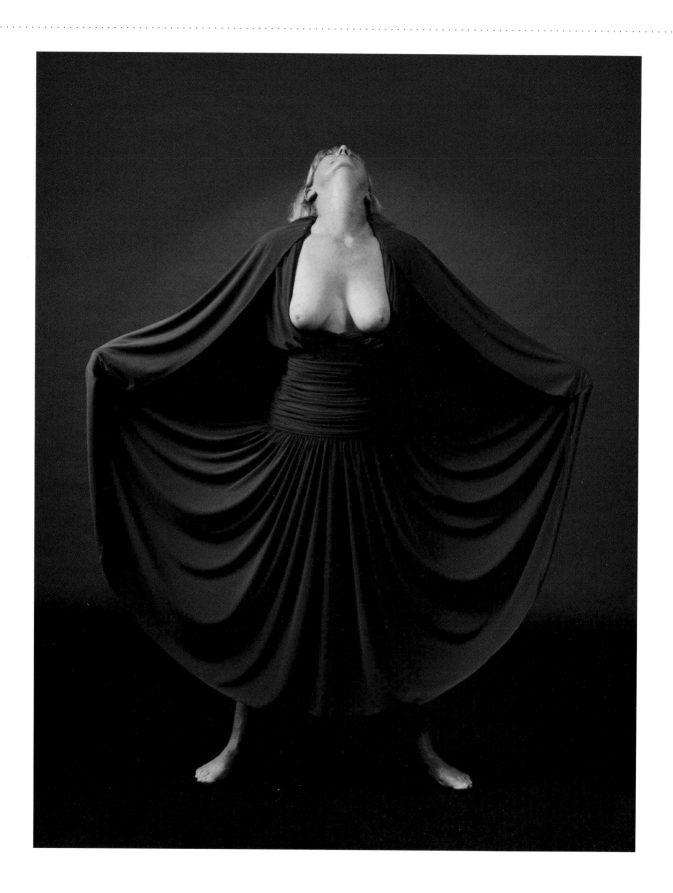

Stephanie

The mammograms were negative and the doctors assured me there was nothing to worry about. However, the quarter-sized lump in my right breast turned out to be cancer.

My breast and right arm took quite a beating after the lympectomy, lymphadenectomy, surgery, radiation and radioactive implants.

Over time my breast has again become fairly symmetrical. Now the solid mass on the outer side of my breast and the occasional ache and swelling in my arm remind me how precious each day is.

– Stephanie

While I was in the hospital shortly after surgery, Cy's aunt was sitting by my bedside. I remember her saying, "Whatever you do, Dora, never let anyone see your scar, and especially never let Cy see it." I was devastated, but Cy being a super husband frowned on that comment. He has shared my problem with me for the past fifty-two years. – Dora

In 1942 when the surgeon called me into his office after completing a mastectomy on Dora, he leveled with me about the prospects for recovery. Even Dora's mother called me aside once and said, "We must not let Dora know that she's going to die." Her concern was devastating to me. I knew, however, that if it were I who faced an unpromising future Dora would be supportive in every way possible. I promised Dora that the operation would absolutely make no difference to me and that we would raise our three children together. – Cy

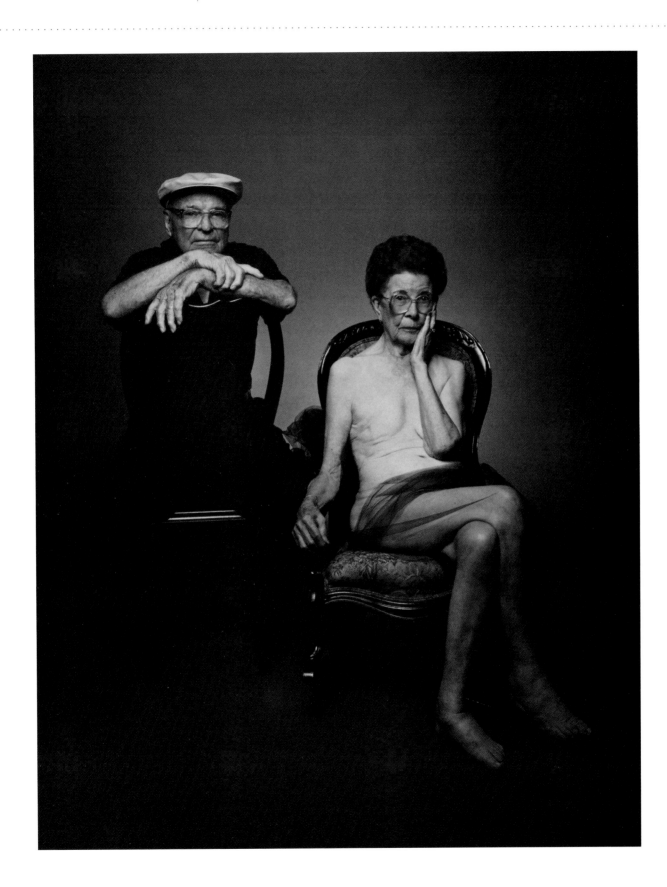

Your hand touched symbols that filled the
air with sonorous sounds.

Your hand touched fountains that drenched the
desert with ample water.

Your hand touched petals that colored the
world with rainbow gardens.

Your hand touched sunlight that brightened
raven tunnels with golden skies.

Your hand touched evening vines that intoxicated
sorrows in desperate towns.

Your hand touched faces that occupied
souls with endless laughter.

Your hand touched mine and softened
this heart once made of stone.

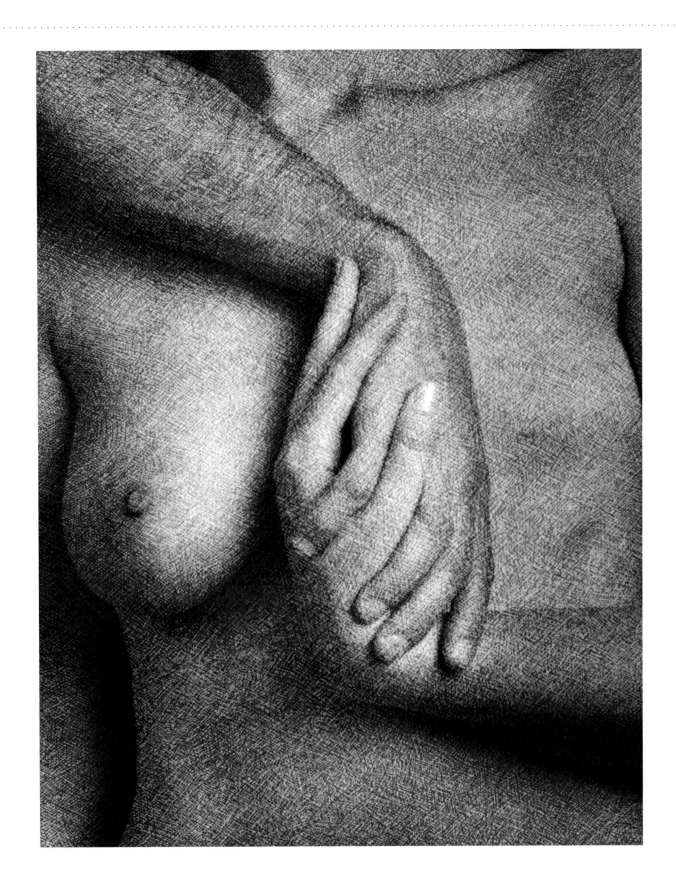

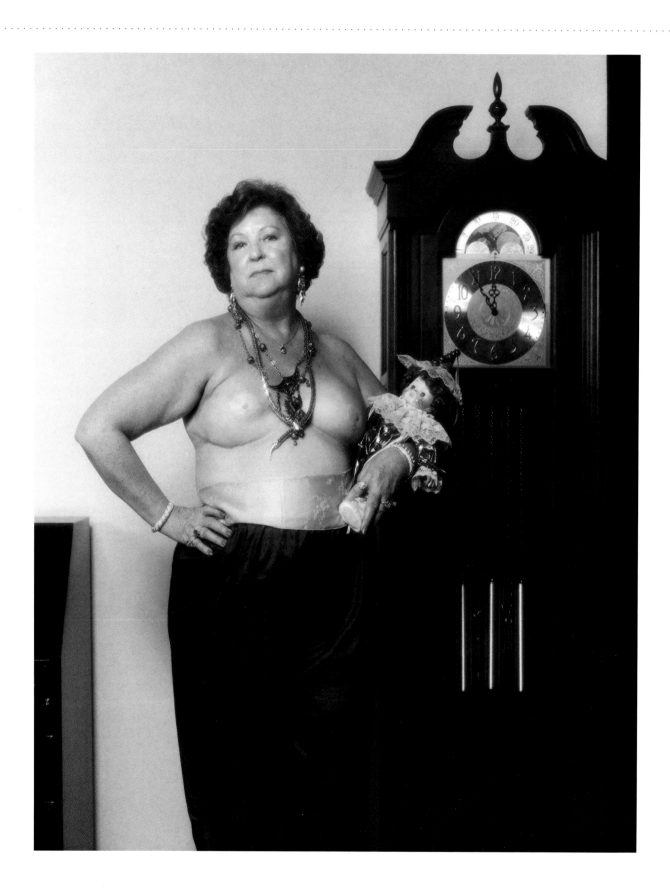

Joel
Reconstructed Right Breast

There is a bright side to everything! When I'm old

and gravity has taken its toll, my implanted breast will re-

main erect like a sixteen year old's. – Joel

When we are at a party and my wife says I can

"nibble on her ear," I know it is time to leave – you see, her

earlobes were used to make nipples for her implanted

breasts. – Doug

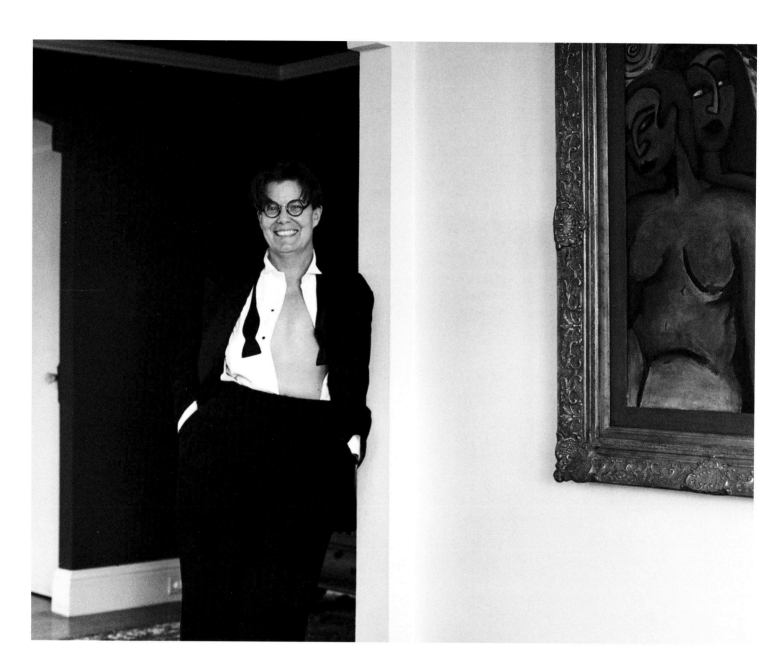

Tanya
Left Mastectomy

*L*ive each day,

each second, each morsel, to

the fullest. Do what you want

to do.

What a gift, at twenty-nine,

to have had to face myself

and ask: what do you regret,

now that your life may be

over? I live now in a manner

that will allow me to answer

that same question – at forty-

nine, sixty-nine, eighty-nine,

whatever age – "NOTHING!"

I'll tell you the honest truth:

I would not undo this gift of

perspective, even to have my

breast back.

I know, now, what is

important, and what is not.

– Tanya

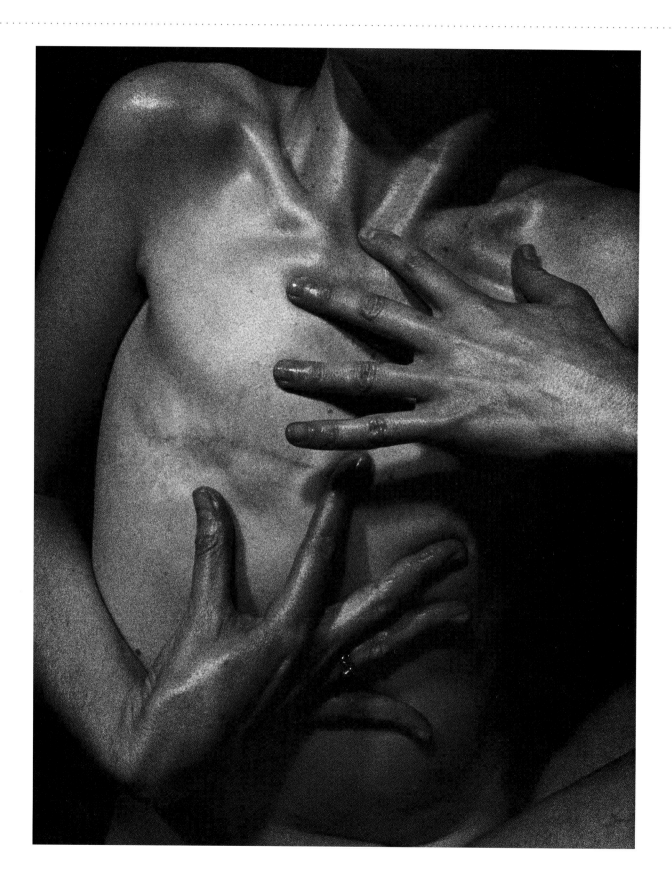

Hands That Still Nurture

I've searched
in many splendid seas
and in many rapturous lands
but no one else has your rhythms,
your shine,
your earth.
Only you captivate the harmony from jaded birds.
Only you bring shade from green forests.
You are pure like a sleepless swan,
true like an undulant river.
You give love like an endless horizon,
you are the feathers that blanket my soul.
You are divine, golden, full.
And your emerald hands continue to nurture me.

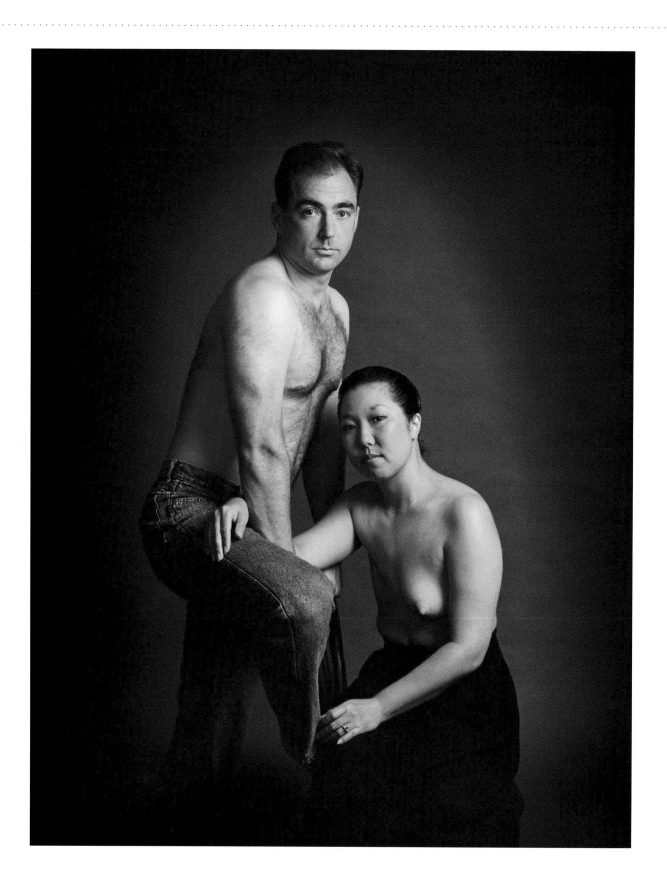

Blair & Susan

Blair was in Naval flight training while I was going through chemo. Flight training is difficult enough, let alone being married – especially if your wife has cancer.

On the day he was "winged," he gave me a dozen roses with a card that said, "You are the wind beneath my wings." Funny – I could have sworn it was the other way around. – Susan

I used to look at Susan and see all the beauty, to long to be with her, to enjoy just touching her, to seek her comfort and warmth, to confide in my best friend, lover and wife. Nothing has changed; I still do all of these. – Blair

Karen
Reconstructed Right Breast

How do I feel when a patient walks into the room for a mammogram? With some patients I am not aware of feeling anything. With others, those in particular who are feeling fear, I feel almost superior. After all I have already been there. I have had breast cancer and I have had the radical treatment of a mastectomy. I now know what I will do in order to survive. I even have a new mound.

Then there are the patients with whom I choose to share my experience. Frankly I am surprised at how many women want to see my reconstructed breast. – Karen

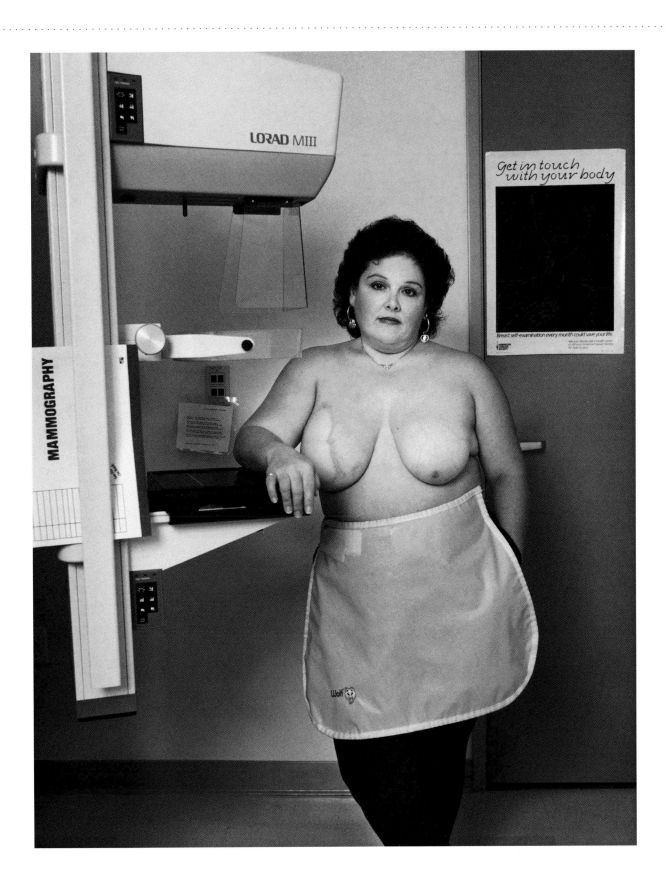

Venus smiles down from
the heavens.
Her cosmic wings agape,
she stares at them.
Oh how beautiful!
She notices a woman
with missing parts.
She senses comfort,
a brilliant glaze.
Her soul moving, this woman,
guided by the spirit of
sun and wind.
She has something of her very own.
It fills her up, it keeps her company.

What a lovely woman,
who sends her freshness
out to the sea,
who transcends humanity
with magical grace,
who naked is worth
a million statues.
A beauty sound like spring
full of incessant gifts.
An ambition higher than
an eager moon.
Venus ascends with calm
thoughts rich in her head.
She whispers,
that woman too is a goddess.

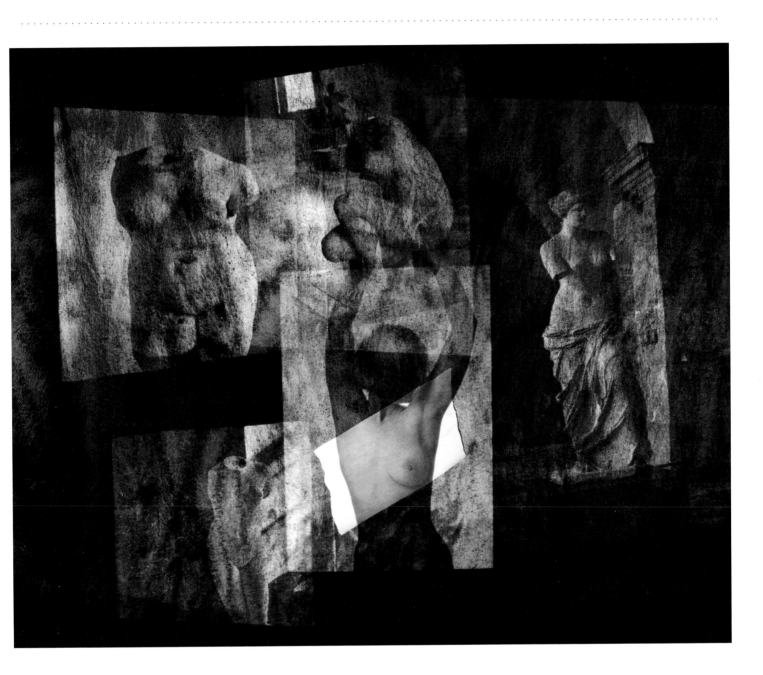

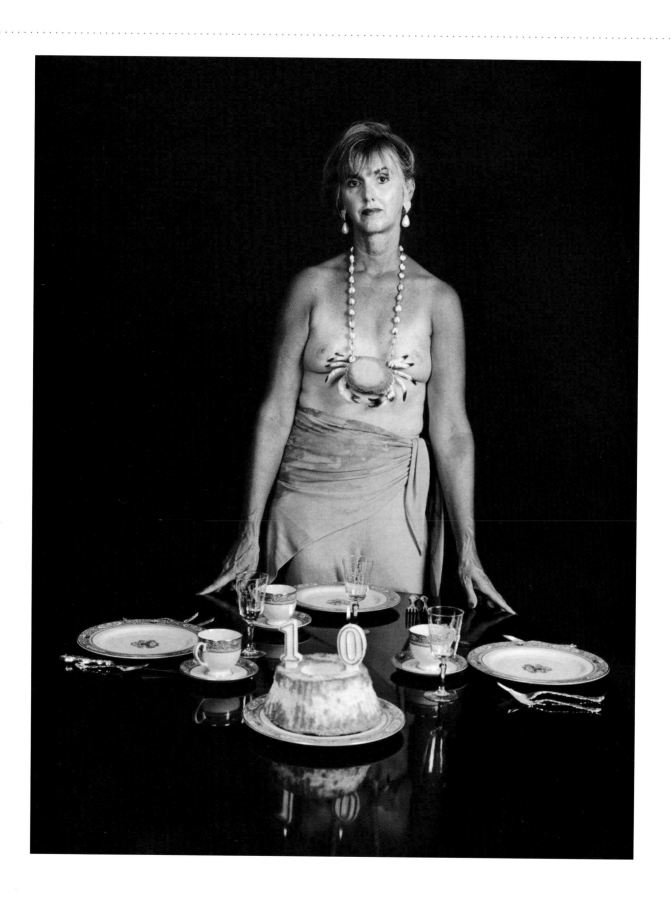

C o n n i e

When I was diagnosed I was devastated. A few years before, I was at my mother's side as she died of breast cancer. She fought her cancer in her own way, with a quiet dignity and unquestioning acceptance.

In my own struggle it was vital for me to become actively involved in my choices and treatment. After reading, talking to people in the cancer field and having several consultations with physicians, I found a team of doctors who viewed breast conservation as a viable treatment option.

The contrast between my experience and that of my mother's has led to some significant changes in my life: I became involved in patient support, returned to school and earned a Ph.D, and wrote my dissertation on "Choices and Options in Breast Cancer Decisions."

If I could give a gift to my sister, daughters and granddaughters, it would be to see me as a living example of hope for the future. – Connie

Andrea & Richard
Double Mastectomy

Andrea was deeply concerned and, at times, depressed about her appearance after the first mastectomy. Aside from empathizing, I can honestly say that I never gave that a second thought. Her breasts never had a great deal to do with my intense attraction for her. Andrea's sexiness emanates from something inherent and essential in her persona. If anything, that energy has been intensified by her struggle to survive. – Richard

It was very funny. I went to the water slides with my eleven-year-old daughter and her best friend, Max. We went down the waterfall, which pushes you up and forward. When I climbed out of the pool, I found that one of my velcroed prostheses was gone! I went over to the young lady in charge and said, "We have a problem – one of my prostheses is in the pool." She looked at me with a question on her face – she had no idea what a prosthesis was. At that moment, Max shouted, "There it is," and sure enough, it was floating toward us on the current. He jumped in and retrieved it for me. Next time I went down the waterfall I held my "boobs." – Andrea

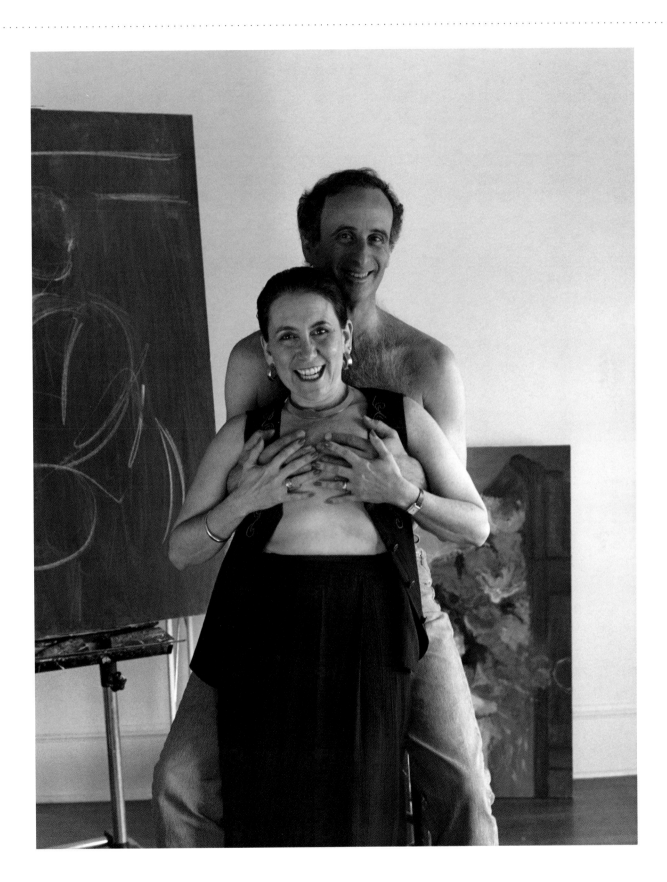

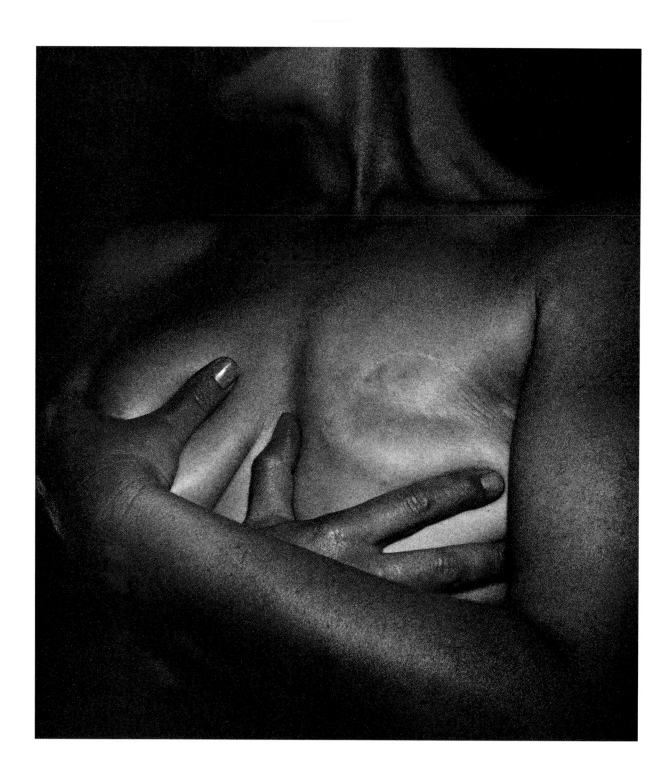

It is her body, her hands

however unshaped and plain,

they are her own.

A body like a sublime cloud that drifts into the cool skies.

Hands like two peculiar plums saturated with sweet dew.

Can she caress?

Yes.

Her fingers make blossoms of everything.

Can her body speak?

Indeed.

Her sculpture lines rave poetic tones.

Can she love?

Completely,

her whole being is a treasure full of

spectacular gems giving the world

immense, peaceful light.

Yavonne
Reconstructed Left Breast

After finishing treatment, I could only think about getting back to my old self again. Being twenty-eight and single I wasn't comfortable with having to stuff one side of my bra and hope it wouldn't move in the course of the day. So having the reconstruction was the ideal thing for me.

My breast wasn't what I missed the most; it was my hair. It was pretty hilarious when it happened. It came out in clumps. I couldn't stand the anticipation of the rest coming out on its own so I called my sister and she came over and looked at me kind of solemn and we both busted up laughing. Then she shaved the remainder off. My two daughters also laughed at this hysterical event.

The funniest thing that happened to me was when my boyfriend spent the night. At that time I was wearing a wig. He'd never seen my head before. One night in bed I had one too many of my hot flashes, as my hormones were all screwed up. I took the wig off while he was asleep and I put it on my pillow. I figured if he awoke I'd put it back on. But I fell asleep, and must have looked like a lollipop laying on a pillow. He woke up before me and he tried to play it off but I know it was shocking to him. We laughed about it later. – Yavonne

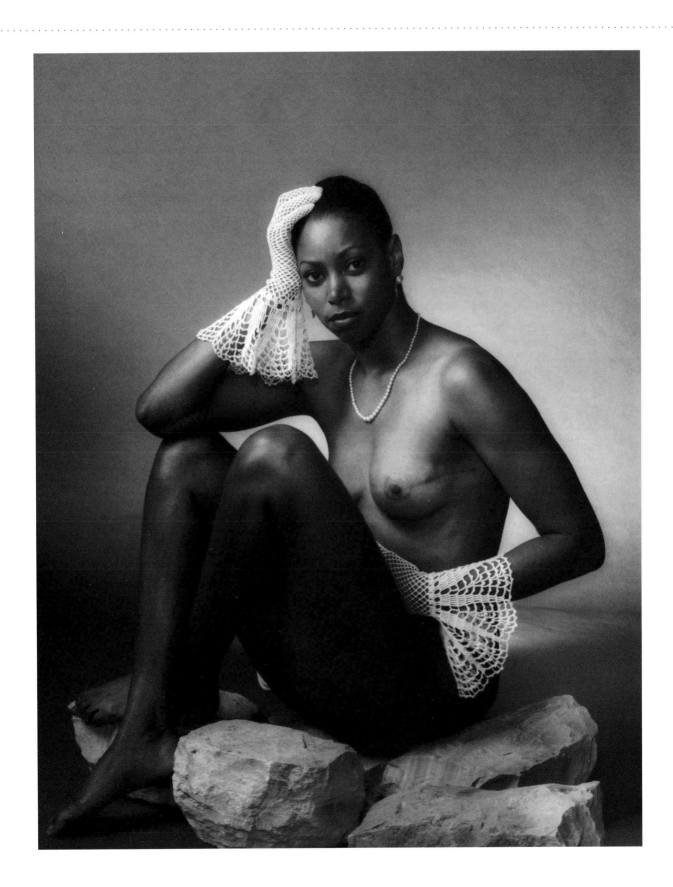

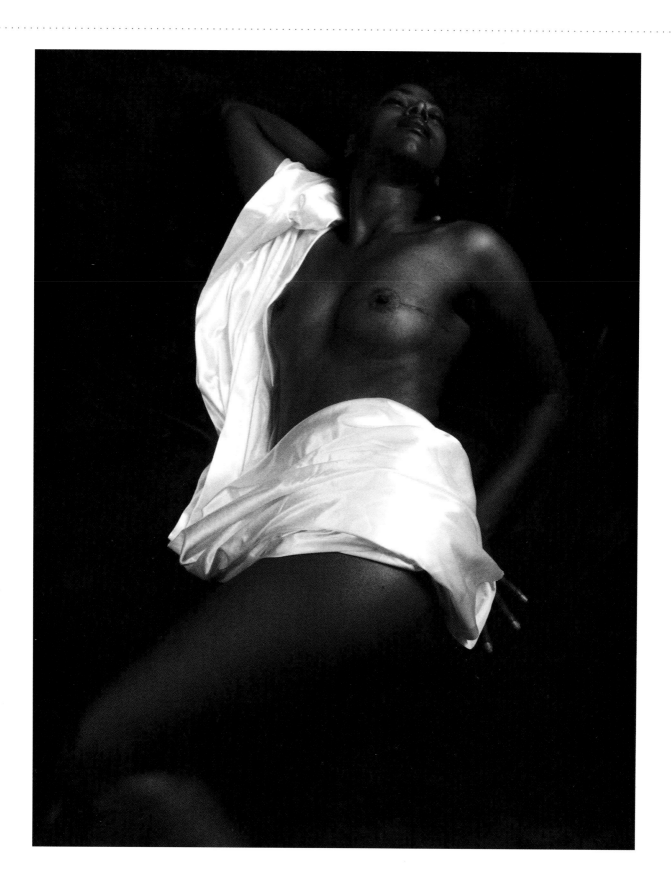

Yavonne

An important part of going through my breast cancer experience was the fact that it did not make me feel unattractive or take away the sensual feelings about myself.

–Yavonne

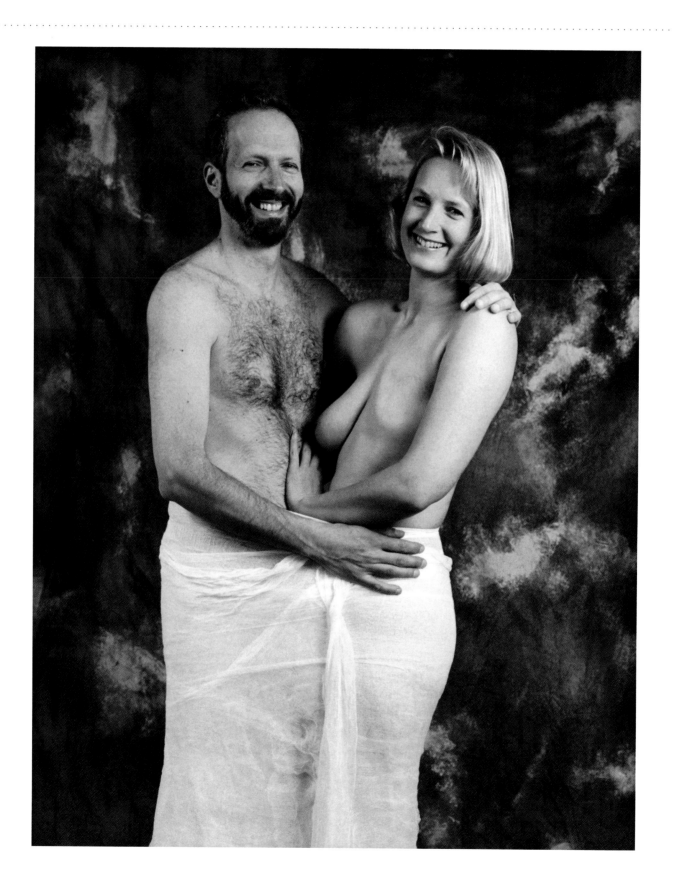

Dani & Ralph

One day, long before I met my sweetheart Ralph, I stood naked in front of the mirror and made peace with the smooth mastectomy scar where my breast once was. I decided to truly feel beautiful.

Later, after a romantic weekend in Mexico, Ralph called to tell me: "I love the asymmetry of your chest." I smiled and laughed to myself – thinking of how hard he must have thought to come up with the perfect compliment. – Dani

I didn't meet Dani until long after her illness, surgery and treatment. What became immediately obvious to me about her was a bright, shining spirit like no one else's. An even greater surprise to me was to learn that this spirit and outlook are infectious. I've caught them too. – Ralph

Nude Reclining in Striated Light

I sat on the edge of the bed, facing away from him. "Ready?" I asked. "I'm ready," he replied, the unwavering tone of his voice giving me a sense of surety. I turned my body to face him. He studied my single breast, then the inverted contour and long scar (I call it my "badge of courage") on the other side with attentiveness and gentleness. Turning his warm gaze toward my eyes, he whispered, "You're beautiful," as he embraced me with all the tenderness and passion that has become us.

It was that easy. I wasn't always sure it would be after my divorce. My (ex) husband had been so understanding and wonderful. But when he left, I had to grapple with the questions that all "single-boobed, single babes" face. Will anyone find me attractive? Will anyone be able to look past the cancer and the scars and see the real me?

Of course I had never lost sight of my beauty. To me, having lost a breast never equated with the loss of my femininity, my sensuality, my strength. It was all there. It is all there. Funny thing is, my personal body image is much better now than it was before. In the past it was always, "I need to lose a few pounds," or "My boobs are uneven." Now I look in the mirror and think, "You look damn good." Even the times - and there are many - when I "forget" and surprise myself looking in the mirror, I have to smile.

We smile a lot, Rob and I. We'll be married April twentieth. – Susan

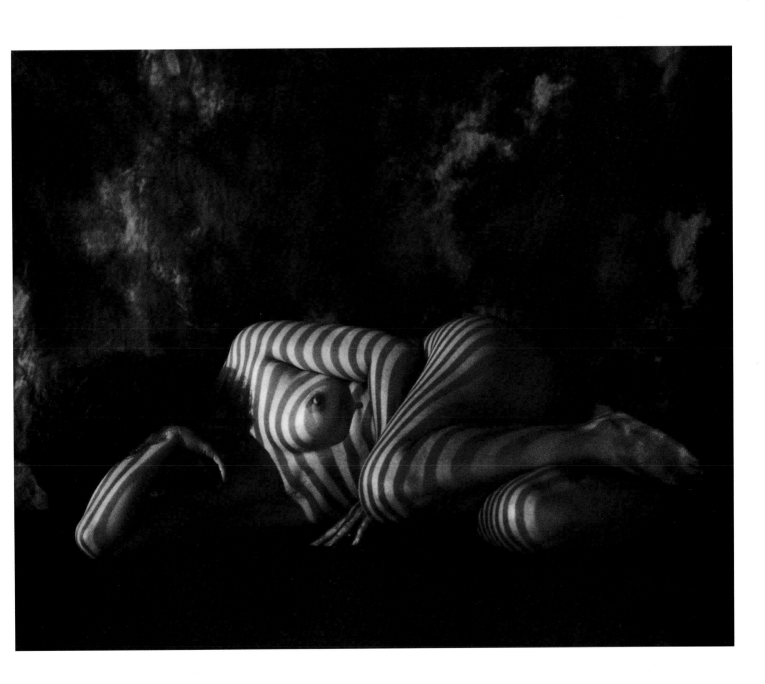

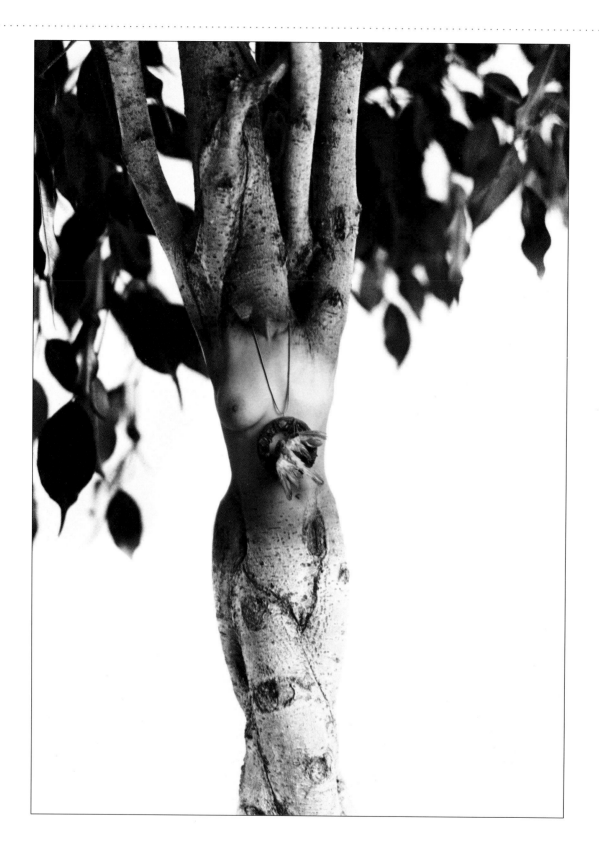

Sometimes an easy comfort
 comes from a stranger's bliss.
Sometimes we know more
 than the highest mountains.
Sometimes courage is just the price of living.
Sometimes our biggest obstacles
 lead to naked paths.
Sometimes the loneliest times
 are when we are surrounded.
Sometimes warm hands
 can quiet angry sirens.
Sometimes being free
 means losing your carefulness.
Sometimes true beauty
 can never be captured.
Sometimes heartache
 is the only way to understand love.
Sometimes our greatest strength
 is in being vulnerable.
And,
Sometimes a leaf will fall before autumn.

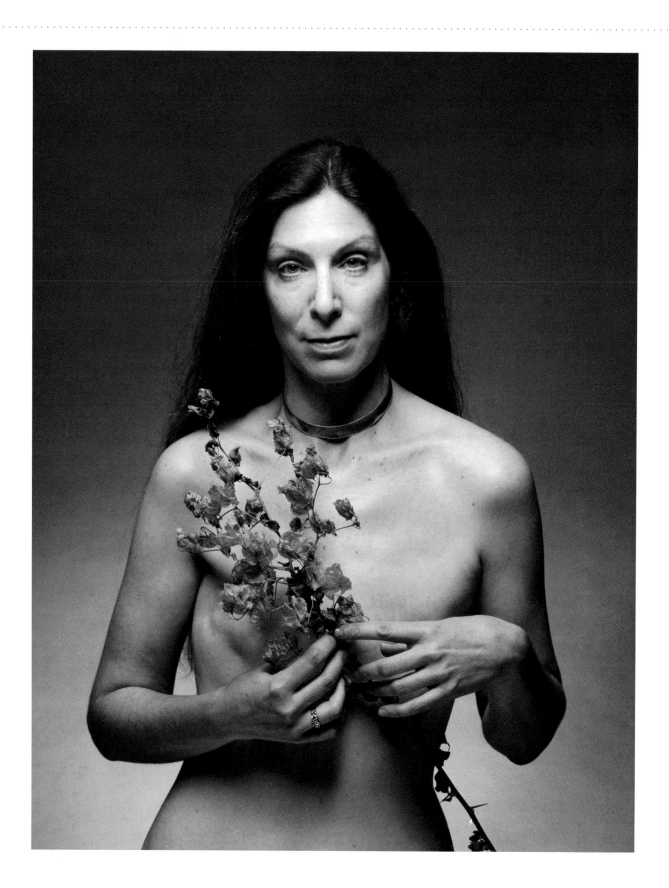

Carol

My first mission was to cut off my waist-long hair and have it made into a wig. I couldn't bear the thought of wearing something that wasn't me. For the longest time, though, I did without it, wearing scarves and hats, and cultivating an exotic look. But soon I was too cold and had to wear the wig. Finally, when I had not a single hair on my head, there was no way to keep the wig on. So I wore colorful, tail-streaming headbands – Indian-style. My first little victory. My hair grew back with a vengeance, thicker and wavier than ever. I still wear headbands from time to time, a reminder and a smile.

I returned to my daily swimming at the gym. Timidly. At first, I went over late at night, when I knew the locker room would be empty. I undressed and dressed under a sweatshirt, maneuvering my clothes like Houdini. Each night I became more daring and went earlier and earlier. Finally I was changing and swimming as I always had. Another little victory. But I couldn't help wondering: if the incidence of breast cancer was one in nine, where, in my fifteen years of swimming, were all the women with mastectomies? Why had I never seen one in the locker room? My fear was born of theirs, as was my sense of disfigurement and embarrassment. But now I had chosen otherwise, and so my victory came, gradually and nourishingly. – Carol

*S*cotty's sportster is fast. The lines to the

bike are straight and hard, which lends itself to being

ridden in the same manner. It suits him because be

likes to ride on the edge, push his limitations. Me, I like to cruise and take

in the scenery. The

shape and lines to my

bike are much different

than Scotty's, full and

round. Scotty says my

FLH rides like a

Cadillac. Both bikes are

powerful and

responsive, but there's a

definite difference in

style and feel to each

bike. I think we both

enjoy the same aspects

of the bikes but for

different reasons. – Lisa

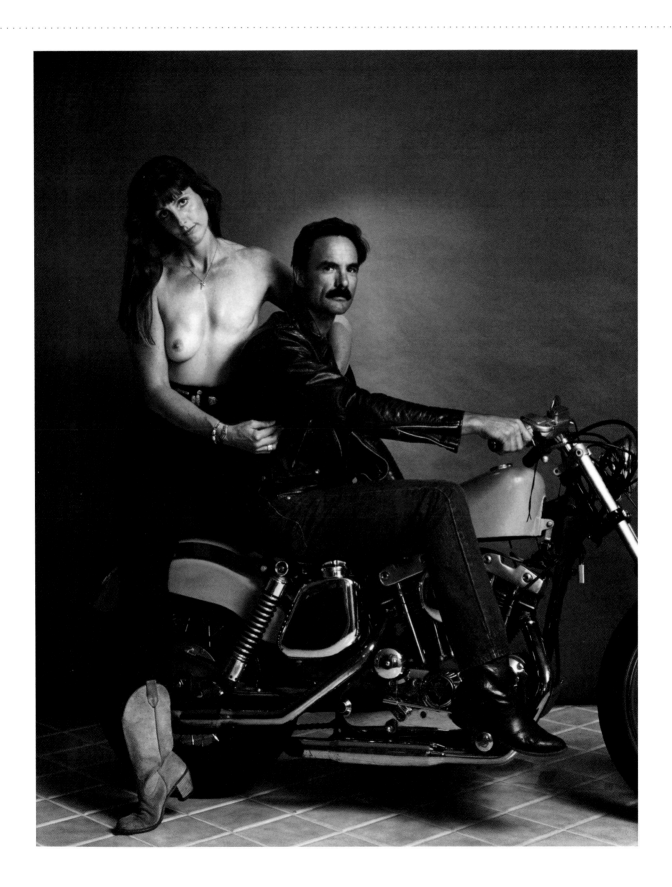

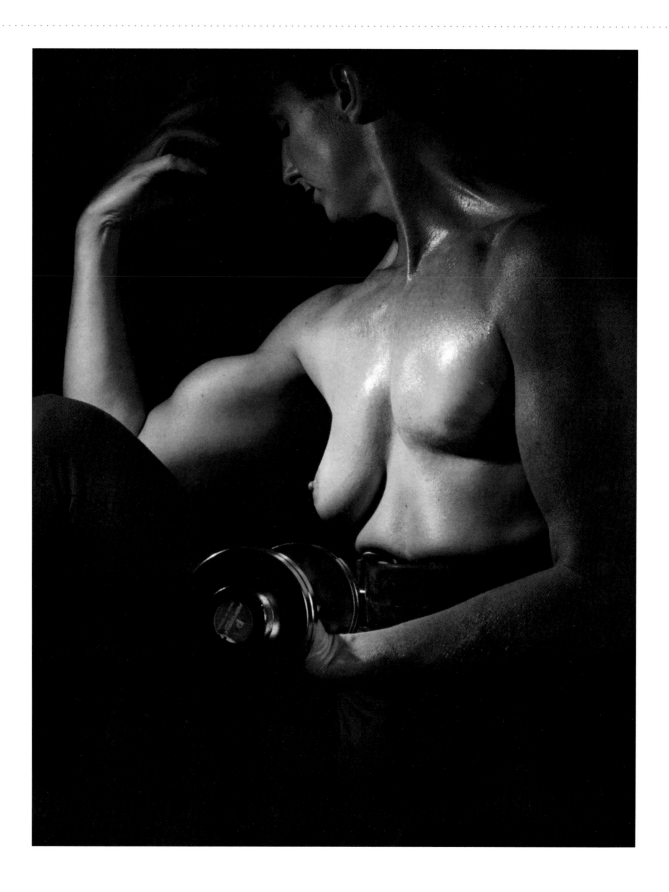

Lisa With Barbell

I've made changes, reshaped my body with the use of free weights and aerobics over the last twelve years. And the surgeon made his changes when he removed my breast. A bit odd perhaps, but I enjoy the change in that when I look at my chest where he removed my breast, I can truly appreciate and enjoy the shape and lines that I have added to my body over the years with the weights. The contrast is appealing to me, a soft breast on one side and a hard "pec" on the other. – Lisa

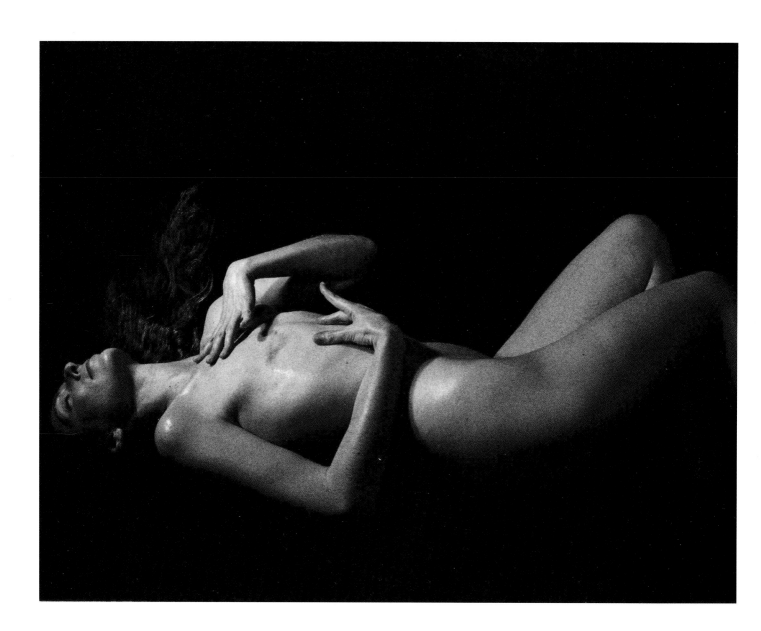

To Touch, Perchance to Feel

See this radiant body,

how I bask in its sensual delight.

Smooth and blush,

with bareness made to tempt.

I stroke this honeysuckle leaness,

and caress at lithe flesh,

only to relish in the pleasure of being a woman.

I feel the warmth. I smell the skin.

It smells like a baby, fresh and innocent.

I touch the softness that changed my destiny,

and think how marvelous to feel, to exist.

My hands break deep into me

reaching my soul.

Reaching this brilliant being.

And all splendid eyelids

are on this perfect woman.

Ulla
Partial Mastectomy

If you look at my photograph I want you to see that breast cancer need not disfigure you or end your life – only as much as you allow it to happen. Cancer is a rough disease to handle! However, you have the choice to enjoy every moment of your life now or let cancer take over. – Ulla

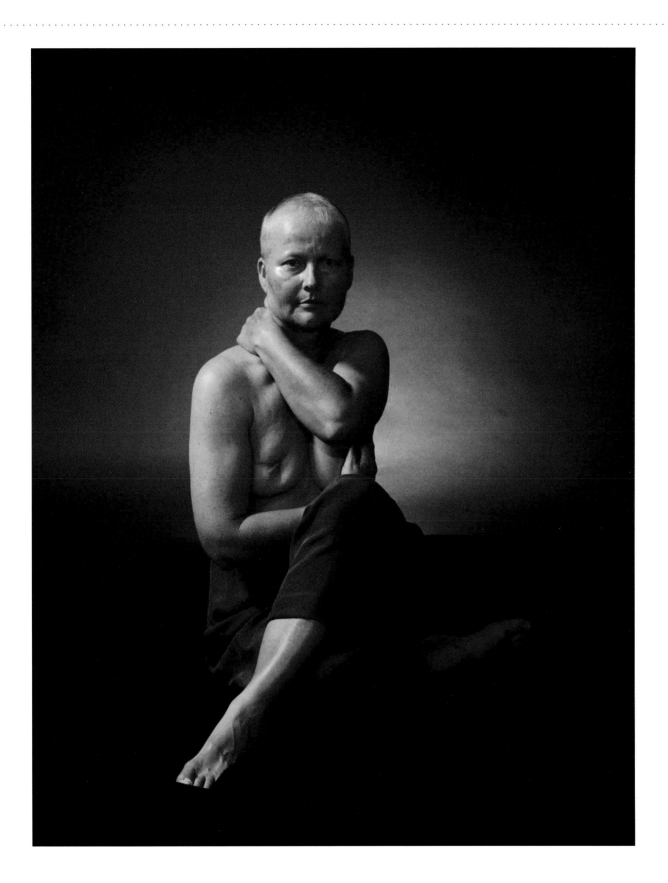

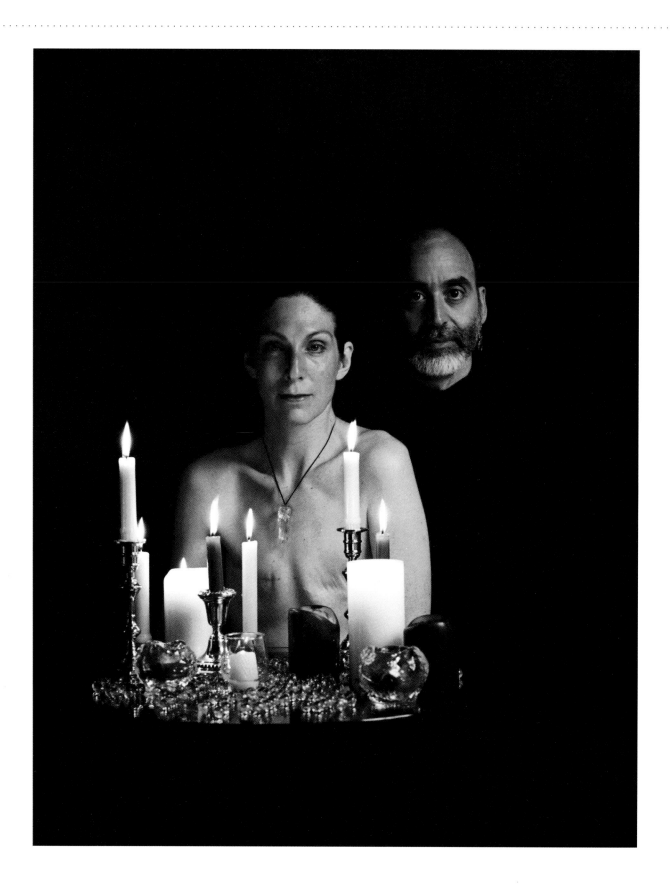

Carol & Dick

Dick, the love for the rest of my life, is my soul-mate. He feels my pain retroactively and yearns to have eased it. But the legacy of that pain is what we share: a zest for life, a compelling belief in the here-and-now, and a knowledge of victory and grace. He has made song of the more the more. – Carol

My mother died of breast cancer and I have always felt that I didn't do enough for her in her waning years. Little did I realize, when I met this lean, flat-chested beauty, that she would be my salvation. Not only has she given me a love that I never thought was possible, but every time I return that love, I feel my mother's spirit shining down on both of us. – Dick

As an avid bodysurfer, I have discovered that wearing a bathing suit top, while required by law, is an incredible nuisance. With only one breast to hold it up, the bathing suit acts as a giant scoop for sand and seaweed. Frustrated, I inquired of an attorney friend what she thought a judge would say if I were to go topless and be hauled into court. She told me that the "standard of proof" is fifty percent plus one, and that I would be always one percent shy of a conviction. She did however, advise me to be as discreet as possible to avoid the fuss of handcuffs and the like.

Topless bodysurfing became part of my routine. One day, while preparing for the World Bodysurfing Championships with a girlfriend, I placed my swimming fins in front of my chest and nonchalantly slipped my top off, keeping my fins up front for cover. As I walked out into the surf, my friend laughed as she dramatically closed one eye and said, "Let's go!"

Art and I decided that we needed a humorous photo in this project to reflect a shared spirit of acceptance. One magical afternoon the three of us served as canvases for the artist, Pam Stuart. Accompanied by a chorus of laughter and giggles, I became "the wink." Carol was transformed into a woman with cleavage in a beautiful blue camisole. This was a special gift to her husband who had met her years after her double mastectomy. Susan, with theatrical flair, became comedy and tragedy, with each intentionally reversed so that the comedy mask appeared over the mastectomy scar.

This trio of "Painted Ladies" shares a poignant bond. From Carol to Dani to Susan, we each served as mentor and friend to each other when we were diagnosed. Years later we celebrated our friendships in living color. – Dani

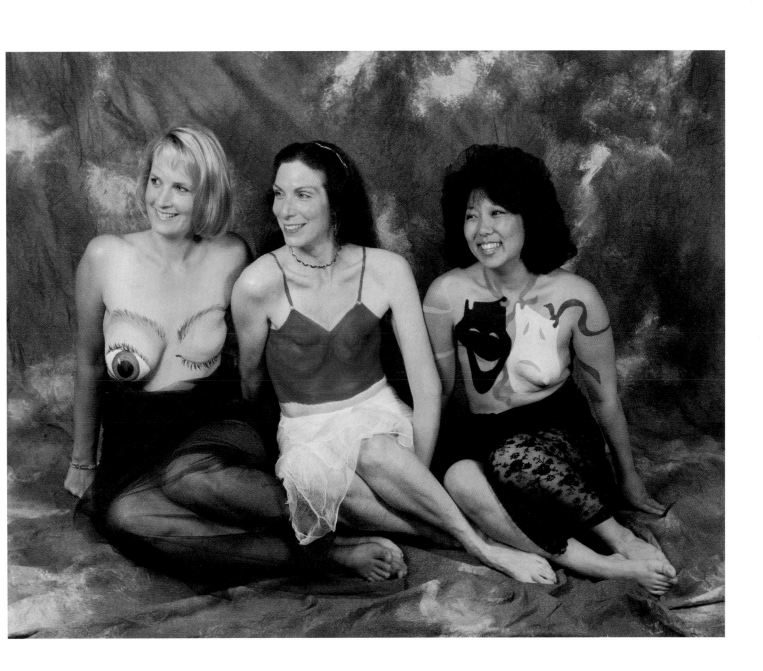

As well as being a fine art photographer, Art Myers is a physician specializing in preventive medicine and public health. He graduated from the Philadelphia College of Osteopathic Medicine and received his post-doctoral degree in public health from the Graduate School of Public Health, San Diego State University. Although largely self-taught in photography he has studied in workshops with Annie Leibovitz, Arnold Newman, Larry Fink, Sally Mann, Joyce Tenneson and other well-known artists. His photographs have been exhibited in galleries and museums in New York, Colorado and California.

Maria Marrocchino works in advertising in New York City. She has been writing poetry since she was a child. This is the first time that her poems have appeared in a book.